PAST PRESENT

FAIRHOPE

T0398492

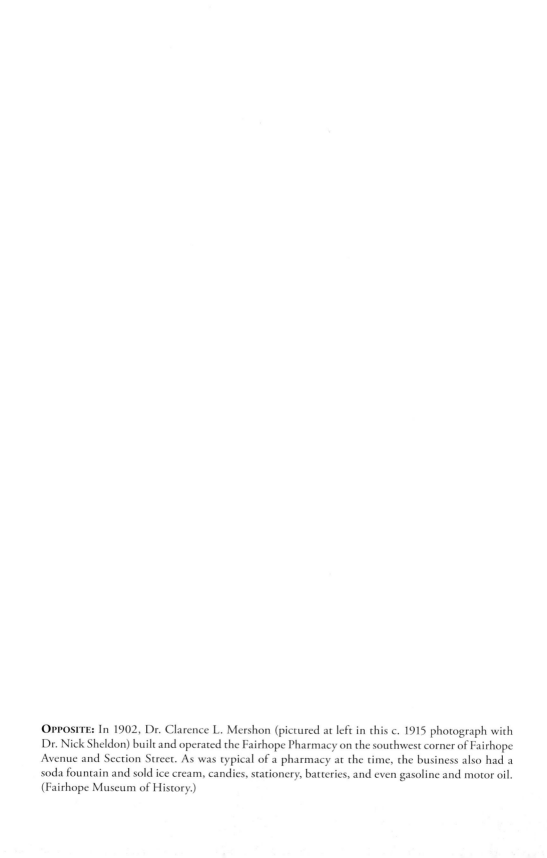

OPPOSITE: In 1902, Dr. Clarence L. Mershon (pictured at left in this c. 1915 photograph with Dr. Nick Sheldon) built and operated the Fairhope Pharmacy on the southwest corner of Fairhope Avenue and Section Street. As was typical of a pharmacy at the time, the business also had a soda fountain and sold ice cream, candies, stationery, batteries, and even gasoline and motor oil. (Fairhope Museum of History.)

PAST & PRESENT

FAIRHOPE

Alan L. Samry and Gabriel Gold-Vukson

To Susan Samry, our Fairhope yesterdays, todays, and tomorrows.

To Lindsay Sherrin, my favorite part of Fairhope.

Library of Congress Control Number: 2023933960

Published by Arcadia Publishing
Charleston, South Carolina

Printed in the United States of America

For all general information, please contact Arcadia Publishing:
Telephone 843-853-2070
Fax 843-853-0044
E-mail sales@arcadiapublishing.com
For customer service and orders:
Toll-Free 1-888-313-2665

Visit us on the Internet at www.arcadiapublishing.com

ON THE FRONT COVER: Two bay boats are tied up in this bustling view of the pier, possibly from the Roaring Twenties, showing bathers aplenty. The building on the right served as the women's changing room. Since the 1960s, restaurants have been located on the Fairhope Pier, including the Yardarm. The Blind Tiger is the latest restaurant group to give the location a go. (Past, Fairhope Museum of History; present, photograph by Alan Samry.)

ON THE BACK COVER: The northwest corner of Fairhope Avenue and Section Street was first occupied by Mershon Bros. grocery and general store. This was the second store in Fairhope and was soon expanded to house the post office. In 1913, the building and business were purchased by Henry Crawford, who sold it to J.I. Pitman in 1920. Pitman had the structure rebuilt in 1929, and it was renovated again in 1939. The building is currently home to Cat's Meow, a clothing store. (Fairhope Museum of History.)

Contents

Acknowledgments

The authors thank the City of Fairhope, the Fairhope Museum of History, the Fairhope Single Tax Corporation (FSTC), and the Fairhope Public Library for the use of these wonderful images. Unless otherwise specified, the past images are from the Fairhope Museum of History collections. Similarly, unless specified otherwise, the present photographs were taken by the authors.

INTRODUCTION

Most towns start with a charter, but Fairhope started with an idea. It even started in a different city and state before any Fairhopers (as the early founders typically referred to themselves) settled on the part of the eastern shore of Mobile Bay that would become the city of Fairhope. Fairhope began in January 1894 in Des Moines, Iowa, with the meeting of a group of devoted Georgist single-taxers—adherents to the economic theories of Henry George—under the leadership of E.B. Gaston. They were not the first to attempt the creation of a single-tax colony in the United States, but they would be among the few that could claim any measure of success. In fact, Fairhope is the oldest and largest of the two existing single-tax colonies in the United States.

The Fairhope Industrial Association, now known as the Fairhope Single Tax Corporation, sent two members from Iowa to find a location to start their single-tax, utopian, experimental colony. The members, James Bellangee and Shuah Strait Mann, recommended a patch of land on the eastern shore of Mobile Bay, between the communities of Montrose (to the north) and Battles (to the south), due to its beauty and economic opportunity. The association agreed, and the land was purchased, in large part, with help from the colony's primary benefactor, Joseph Fels. In November 1894, twenty-eight individuals, including children, left their homes from several different states and traveled to the colony.

While it was said that the experimental single-tax colony had just a "fair hope" of success, this was proven to be an underestimation. Most of the early single-taxers were Midwesterners of modest means. They were not showy but rather practical folks. Yet, under strong leadership and an inspiring organizational constitution, they managed to build a community in the midst of a deforested acreage that had been known as Stapleton's Pasture.

Located alongside (and predating) the colony were the Black communities of Houstonville, Twin Beech, and Tatumville. These communities, which still endure today, had their own cultures and leaders as well as churches, schools, businesses, and community buildings. Fairhope, like most Southern towns, long kept the community separated along racial lines. This has limited the photographic evidence of the Black community's presence in Fairhope. However, although they may not be adequately represented in images, the Black community's presence and contributions are undisputed inside and outside of Fairhope.

In 1899, well-known feminist, utopist, author, and book collector Marie Howland moved to Fairhope. In 1900, she opened her home and her collection of 1,200 books as Fairhope's first library, beating the City of Mobile by two years. By 1908, the collection and the community had outgrown Howland's home, so a new library was built in front of her cottage—a testament to the value of books and lifelong learning.

In 1902, a top-ranking educator, Marietta Johnson, moved to Fairhope, and in 1907, with the help of another notable educator, Lydia Comings, she opened the world-famous School of Organic Education. The school was praised by, among others, John Dewey, C. Hanford Henderson,

Clarence Darrow, Clara Bryant Ford, and Upton Sinclair, who enrolled his own son at the school. The "dean of American craftsmen," Wharton Esherick, received his first chisels there. After 116 years, the school is still operating today.

By 1908, the successful establishment of the single-tax colony had attracted some who were not single-taxers but were looking to take advantage of the colony's rewards without participating in the mechanism that created them. Additionally, schisms had appeared between devotees of other reform movements and single-taxers as well as between the purist single-taxers and the pragmatists. The result was the establishment of the City of Fairhope—a municipality in and around the Fairhope colony. The city took over public utilities, services, and infrastructure, and the corporation, now a 501(c)(4) nonprofit organization, collected (and continues to collect) an annual "demonstration fee," based on land value, on land it owns. The purpose of the demonstration fee was—and is—to demonstrate the usefulness of the single-tax concept through community-benefiting projects such as parks, museums, libraries, hospitals, sidewalks, and contributions to charitable organizations.

Fairhope experienced a surge in popularity in the late 1910s and through the 1920s that was well documented by a photographer named Frank Stewart, known as the "Picture Man." Stewart photographed buildings, streets, schools, both horse- and gas-powered vehicles, Fairhopers, bay boats, and more. Those photographs were printed on postcards in large numbers, which, fortunately, increased the number and quality of surviving Picture Man images. Stewart's name can be seen etched in white at the bottom of many of his photographs.

For a long time, Fairhope was a slow-growing small town with a successful tourism industry and a lively downtown. Since 2000, however, Fairhope's population has doubled, and both the city and its county (Baldwin) are among the fastest-growing areas in the state of Alabama. With that growth has come a level of unprecedented development. While many historic structures have been lost, many that have survived are included in this book.

BAY VIEWS

The steamship *Fairhope* is shown docked at the Fairhope wharf while swimmers enjoy diving off the pier and the ship's bow. The 94-passenger steamer was constructed in 1901 on Fairhope's North Beach. Unfortunately, the ship caught fire while docked at the wharf in 1905 and eventually sank off the Battles sandbar. (Fairhope Single Tax Corporation Online Archives.)

An iconic view of the Fairhope pier shows Mobile Bay bathers and boaters having a grand time. Originally a wharf used for commerce and paid travel, the pier was one of the colony's first projects and a necessity for Fairhope's survival. Until 1927, when the causeway was built across Mobile Bay, bay boats were the only practical means of travel to the eastern shore. Without a wharf where vessels could land, Fairhope would have missed out on valuable wharfage fees and tourism.

As Fairhope's popularity grew, the bay boat industry became more competitive, and bay boats were soon traveling back-to-back, as shown here. Wharf Hill was developed to capture the attention of travelers as they arrived and provide locals with bayside entertainment. Berglin's, located on the right side of the beach at the end of the pier, sold ice cream on the bay. The Fairhope Casino, shown here with the large Coca-Cola sign, housed a dance hall, restaurant, and bowling alley.

Up the Hill With a Load ~ Peoples R.R. Fairhope Ala

Stewart The Picture Man

From 1914 until 1923, passengers and cargo arriving at Fairhope's wharf could travel by rail up Wharf Hill and into downtown Fairhope. The People's Railroad was owned by the Fairhope Single Tax Corporation and ran from the pier to Bancroft, traveled around the Organic School, then ended on School Street. The train car itself was built at Frank Brown's sawmill. Although it was originally intended to extend to Robertsdale, the railroad was (surprisingly) never profitable.

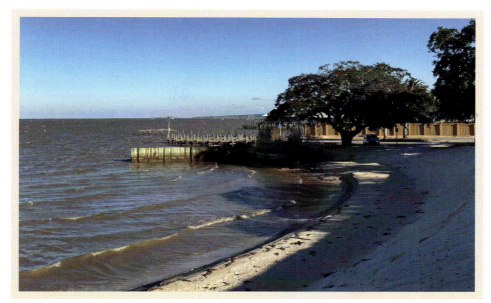

Magnolia Beach, located in the southern part of Fairhope along Mobile Bay, had a privately owned pier. This pier was built in 1914 by the Magnolia Beach Pier Company and bought the next year by Anna Fermann, who had the pier renovated and had bathhouses and a dancing pavilion built. Charles and Maude Burkel purchased the pavilion in 1927. Burkel's Pavilion included a dance hall, skating rink, and Civil War museum. Burkel's burned down in 1952.

The iron-hulled steamer *Fairhope II* (formerly the *William H. Welch*) was christened on Christmas Day in 1906. Purser Joseph M. Pilcher's wife, Anna G. Pilcher, "smashed a bottle of wine over the bow of *Fairhope*," according to the *Fairhope Courier*. It was taken out of service in 1911.

Skip Jones is the proud restorer and owner of the coastal cruiser *Delores Catherine*. The 1936 converted Covacevich shrimper is still named after the daughters of the boat's first owner, Richard Purchner. (Present, Dunn Hester.)

STEAMER FAIRHOPE

Stack's Gully runs parallel to Fairhope Avenue near the bay. The ravines remain an integral part of Fairhope's natural drainage system. This photograph looks northeast on Bayview Street. The Mogg home, built in 1908, is on the far left, and the Baptist church is on the right. The homes on the corner of Bayview and St. James Streets were built by Dyson and Sons in the 1920s using a local, orange-colored structural clay block called Clay City tile.

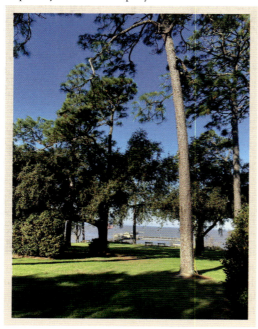

Part of the reason Fairhope remained attractive to visitors was the bay breeze that blew along the bluff, even during stifling summers. Many Mobilians escaped the summer heat by spending the day in Fairhope. People gathered for bayfront events like the Fourth of July, just as they do today. Henry George Park, which has an obelisk monument honoring its namesake, is a gathering place for local markets, movie nights, Baldwin Pops concerts, and performances by the Eastern Shore Repertory Theatre Company.

CHAPTER 2

PLACES TO STAY

George and Delia Bancroft built Fairhope's first hotel. The Fairhope House, or Fairhope Hotel, was constructed in 1898 on the northern side of what is now Henry George Park, which is generally referred to as the Bluff. This popular place with the best bay views had many additions over the years until it burned down in 1910. (Fairhope Single Tax Corporation Online Archives.)

The Colonial Inn was Fairhope's finest hotel for eight decades. Located at South Mobile Street and Cliff Avenue, the inn was constructed in 1909 overlooking the bluff and a short walk from the pier, which offered panoramic views of Mobile Bay. The Sacriste sisters, Ann Morgan and Vienna McClintock, ran it for several decades, followed by Edward and Julia Overton, who owned and operated the idyllic location from 1942 until it was demolished in 1992. The condominiums were constructed in 2017.

In addition to the Colonial Inn proper, which included areas for lodging, dining, and entertainment, the Colonial Inn Cottages, shown in the image above, were located behind the inn along Cliff Drive south of Stack's Gully. The inn was located to the right of the location shown in these pictures, which were taken from the corner of Short Street and Cliff Drive and east of the former inn location. (Past, Fairhope Single Tax Corporation Online Archives.)

The home of Dr. R.A. Hail, located at 208 Fairhope Avenue, became a hotel called the Kanuck, a slang term for a Canadian. William and Ellen Jardine's hotel had an extensive list of amenities that drew tourists from 1916 to 1953.

"Centrally located, steam heated, electric lighted, bath, hot and cold water throughout," bragged a *Fairhope Courier* hotel advertisement from 1918. It was a regular stop on the People's Railroad.

PLACES TO STAY

The first known structure at 312 Fairhope Avenue was a hotel called the Wilson House, first mentioned in the *Fairhope Courier* in 1907. In 1913, it was renamed the Royal, and in 1920, it became the Boston Café. In 1921, it became the Tumble Inn, then the Norton House in 1925. It became the Dixie Hotel in 1932, which lasted until 1959, when the name was changed to Saratoga Trunk Inn. The building was later demolished, and the current building was constructed in 2005.

The home at 106 Magnolia Street was built around 1910 by Alexander Melville. The home was sold in 1914 to J.J. Murray and became the Hotel Murray. The hotel was sold in 1917 to William and Elva McIntosh. The McIntoshes renamed it Laddie Lodge—for their five sons—and lived in the home until 1960. William McIntosh was active in the community, served as mayor, and was an officer and founder of the Bank of Fairhope. (Past, Pinky Bass.)

Whittier Hall, sometimes called Whittier House (after A.N. Whittier and his wife, Carrie), was built in 1905. The Whittiers, who bought the house in 1910 from W.W. Kile, not only catered to tourists but were also active and involved single-taxers. Since their house was across the street from the library, they hosted many lively discussions with locals and visitors. The former hotel at 201 Magnolia Avenue is now a private residence. (Past, Fairhope Single Tax Corporation Online Archives.)

C.G. and Matilda Larsson, natives of Sweden, purchased land in 1904 that included the Volanta Hotel. In 1944, the Larssons retired, and 601 North Mobile Street was purchased by Dr. H.C. Jordan. In 1949, it became the home of the newly formed Gaston-Lee VFW Post 5660. Since 1987, after extensive renovations, it has served as a bed-and-breakfast and a private residence. (Past, Historic Mobile Preservation Society; present, Dunn Hester.)

Lee Parker and his wife, Ethel, opened Parker House Restaurant and Motel in 1946 and 1950, respectively. The place attracted locals and tourists and was situated on eight acres on what was then called Highway 89, the scenic route between Mobile and Pensacola. The family-run restaurant, which promoted "curb service," had the "South's finest foods" including steaks, fried chicken, and homemade pies. The couple ran the family restaurant and motel with "air-conditioned rooms" until the 1970s.

The Grand Hotel opened in 1847 as a 40-room hotel with a separate kitchen and dining room and a bar called the Texas. In 1864, part of the hotel served as a hospital during the Civil War. Over the years, all three buildings suffered damage or demolition from fires and hurricanes, and the hotel was repaired and rebuilt several times over the last century but has remained a hotel. Today's award-winning Grand Hotel Golf Resort & Spa has 405 rooms, a spa, and convention space.

rand Hotel and Beach - Point Clear, Ala. 2-A-16

BUSINESSES

This photograph of Fairhope Avenue, facing west, was taken by Frank Stewart from the top of a water tower that once stood near the present-day Welcome Center. The completion of the Mecca, the Forster filling station on the southwest corner of Fairhope Avenue and Church Street (now Sandra's Place), indicates that this photograph was taken in 1934 or later.

Fairhope's first ice plant, shown here in 1910, was put into operation in 1909. The plant, which was located on the beach near the Fairhope pier, was operated by the Fairhope Ice and Creamery Company under Adolph O. Berglin, who started the Fairhope Creamery in 1908. Operations were split between this location and a newly acquired location on Fairhope Avenue from 1926 until this plant was removed in 1933. The current building was constructed in 1960.

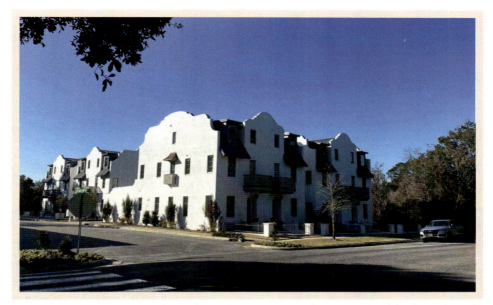

Klumpp Motor Company, located on the southwest corner of Bayview Street and Fairhope Avenue, was owned and operated by T.J. Klumpp, who also served as mayor. Fairhope Garage and Livery was built in 1912. Klumpp bought the Fairhope Garage from D.A. Russell in 1917 and opened one of the first Chevrolet dealerships in Alabama. A few of those early junkers are buried in Stack's Gully behind the current building. (Past, Fairhope Single Tax Corporation Online Archives.)

George Knowles tended a farm on the southeast corner of Fairhope Avenue and Bayview Street. Frank Zanders built the Rialto hotel in 1914. It was acquired by G.W. Gore in 1920 and renamed the Gore Hotel, which burned down in 1924. A Sherrill's Service Station was built on the site in 1926. Klumpp Motor Company purchased Sherrill's, expanded its services, and opened Klumpp Super Service Station. An office building occupies the site today, but the Fairhope Avenue concrete service island remains.

A Mobile Medical College graduate, Dr. Claude George Godard first practiced medicine alongside Dr. Clarence Mershon, who operated Fairhope Pharmacy. During World War I, Godard served in the 52nd Infantry Division. Upon his return from service, he opened his drugstore and medical practice in this new building at 122 Fairhope Avenue. Dr. Godard served his community for over 50 years. The building later became Moyers Drugstore and is now the office and theater for the Fairhope Film Festival.

Originally known as the Titus Building, this structure on the southeast corner of South Summit Street and Fairhope Avenue was erected in 1921 and housed the Cooperative Store until it moved to a new location in 1922. In 1924, the Metropolitan Restaurant (also known as the Metropolitan Café or Metropolitan Bakery) took over the building. The Metropolitan Restaurant was owned by Jason Malbis, for whom the Malbis community of Baldwin County is named. Today, the building is being used by a photography company.

The building at 212 Fairhope Avenue was constructed in 1949 by Jesse Burke. It was the Launder-Rite laundromat with the "30 minette wash," according to a 1950s advertisement in the *Fairhope Courier*. The building later became Hunter's Coin Laundry. Gavin Hunter owned and operated several laundromats around Fairhope, but this location closed in 1973. Robert Mason built the structure at 214 Fairhope Avenue in 1946. In this 1955 photograph, Bagby and Son's, a Sherwin-Williams paint store, occupied the building.

The House of Ten Gables was an inn and boardinghouse run by Samuel and Lydia Comings on the southwest corner of Fairhope Avenue and Church Street. Later, the Gables was run by Jack Cross and his wife, Eloise. Gulf oil dealer and contractor Oswalt Forster built the Mecca Service Station in 1934 on the corner location. In 1975, Jeane Byrd opened Jeane's Decoupage, which sold arts and crafts supplies and offered community classes. Sandra's Place opened in 1996.

In 1924, the Magnet Theater was built by Judge Edward P. Totten on the southeast corner of Church Street and Fairhope Avenue, which was previously part of the residence of A.O. Berglin. A restaurant called the Tea Tile also operated out of the theater building. Over the years, the theater was renamed the Playhouse Theater, then the Fairhope Theater, and housed several shops. The building caught fire in 2011, and a new structure was erected in 2015.

CHRISTIAN C

The northeast corner of Fairhope Avenue and Church Street was first home to the People's Cooperative Store and bakery, built in 1922. It also housed the People's Cooperative Restaurant. In 1929, the building was Hammond's Store until it was bought by Curtis Rushing, who ran a grocery store there. A Piggly Wiggly occupied the building from 1951 until 1958, then a succession of department stores moved into the location. Fairhope Hardware used the building from the 1980s until 2017.

Walker Furniture Company opened in 1921 and was the first business located at 311 Fairhope Avenue. In 1922, future Fairhope mayor Tony Klumpp moved into the building and operated an automotive dealership. In 1923, the building was taken over by the Eastern Shore Café, which changed hands in 1929 and was renamed Nottleman's Café in 1931. It was the neon-signed and pink-colored Central Restaurant for several decades. Today, the building houses the Bone and Barrel restaurant.

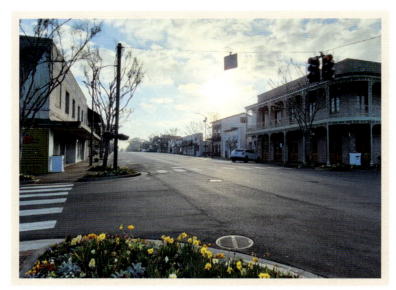

The original building at 306 Fairhope Avenue was constructed in 1921 by E.A. Ruge and used as one of two locations for the People's Cooperative Store. The store moved that same year, and the building became a bakery and barbershop. From 1927 to 1937, the building housed Taylor's Restaurant, and in 1938, a new building was constructed by Dyson and Company. The Fairhope Men's Shop was there until 1950. Since then, it has housed clothing, jewelry, and photography shops.

The Fairhope Market, shown in this mid-1920s photograph, sat on the lot of 380 Fairhope Avenue, which is currently occupied by M&F Casuals. The Fairhope Market was once a meat market run by Don Nelson and Horace Wilson. Wilson later sold his share to Ed Leavins, and the name was changed to Fairhope Meat Market. In 1940, the building was altered and became a Western Auto Store.

Built in 1934, the structure at 335 Fairhope Avenue first housed the Fairhope Coal and Supply Company, which changed its name to Fairhope Hardware and Supply Company in 1946. The company later moved a short distance down the street to 301 Fairhope Avenue, where the People's Cooperative Store was once located. The building is currently occupied by a toy store, but the word "Hardware" remains embossed above the display window.

The brick building containing 382, 384, and 386 Fairhope Avenue was constructed in 1927 and referred to as the John Lawrence Building. Upon opening, it contained several offices for rent and the local offices of the Bell Telephone Company. The Soda Garden, shown here, opened in 1943 and replaced Brad's Ice Cream Parlor (which was formerly Funk's Ice Cream Parlor). Today, the building houses an art gallery and a clothing store.

The lot at 396 Fairhope Avenue was once covered by an extension of the Fairhope Pharmacy that served as a café. However, in 1927, the new Bank of Fairhope was built there. The bank moved to a newly constructed building at 387 Fairhope Avenue, and in early 1959, the Fairhope Finance Company moved in. Many Fairhopians recall the former bank housing the *Mobile Press-Register* offices. Today, the building serves as the Christmas 'Round the Corner.

BUSINESS SECTION, FAIRHOPE, ALA.

A.B. Call's millinery shop was built in 1901 at what is currently 387 Fairhope Avenue. Call later converted the business into the Pinequat Shop, which sold candies and gifts. A new building was erected there in 1959 by the Bank of Fairhope (later First National Bank of Fairhope). The City of Fairhope purchased the building in 1972 to use as a city hall. It soon returned to bank use, was altered in 2005, and currently houses Truist Bank.

The original wood structure of the Fairhope Pharmacy, built in 1902 by Dr. Clarence L. Mershon on the southwest corner of Fairhope Avenue and Section Street, was replaced in 1916 with the white cement-block building shown here. A small café extended from the pharmacy for several years before being replaced by the bank building. The Fairhope Pharmacy is still at the same location today. Although ownership has changed several times, the building has retained its original name and function.

This unique 1936 image of Gaston Corner (with two water tanks) shows where the Fairhope clock is located. The Gaston Motors gas station is on the right. The Fairhope Power Plant is in front of the water tanks on the left. The older tank on the left was built in 1916 to replace the first tank, which was located in the middle of this intersection. The 1916 tank was dismantled shortly after the new tank went into service.

The Wheeler Mercantile was built in 1918 on the southeast corner of Fairhope Avenue and Section Street. It was later called the Corner Cash Store. The wood structure was demolished in 1928. The present building, originally George McKean's Hardware, was constructed in 1931. The Fairhope Esoteric Society met upstairs. The hardware store closed in 1971, and the building was subdivided into several stores and upstairs apartments. The corner store, Gigi and Jay's, has been at this location for more than a decade.

This 1931 photograph shows Ford's 20-millionth produced car stopping at Gaston Motor Company during its nationwide tour. Gaston Motor Company, started by James E. Gaston, opened in 1914 as Gaston's Auto Livery in a small building around what is now 405 Fairhope Avenue. The business was soon renamed Gaston's Garage, then Gaston Motor Company. The building was enlarged in 1925 and remodeled in 2021. Currently, the building houses three separate business spaces.

The building at 412 Fairhope Avenue was erected in 1903 by W.A. Baldwin to be used as his residence. In 1922, the building was moved several feet to the east by its new owner, Dr. Floyd Moore, and converted into the Fairhope Café. In early 2023, the building was demolished, and a three-story retail space was planned for its lot. (Past, Fairhope Public Library.)

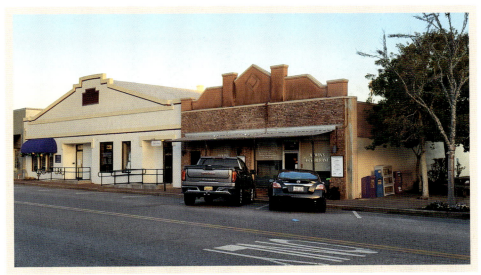

Located near 411 Fairhope Avenue, where Julwin's restaurant now stands, was a blacksmith shop owned by Roscoe Keller starting around 1910. In 1911, Kingsley B. Vanderslice of Chicago purchased Keller's tools and rented the shop to start his own blacksmithing business. Vanderslice offered horseshoeing, tinwork, and plumbing. In 1916, the shop caught fire in the early morning and burned to the ground.

The Farmer's Cooperative Creamery Company, incorporated in early 1922, opened a brand-new creamery plant in June of that year on the northwest corner of Fairhope Avenue and North Bancroft Street to sell Azalea Brand products. This picture was taken around 1925—the year the organization went out of business. The facility was purchased by Fairhope Ice and Creamery in 1926 under A.O. Berglin. The plant was closed in 1963, and the area was paved over in 1987.

The southwest corner of Fairhope Avenue and Bancroft Street was first occupied by the Winter's Service Station's second location in 1926. A year later, the service station was reopened and renamed Tuveson Brothers Garage by the Tuveson family of Fairhope. In 1939, the Graham Oil Company began operating out of the building. Between the 1970s and 1990s, the building served as an automotive supply shop. The building was remodeled in the 1990s and now houses a Honey Baked Ham.

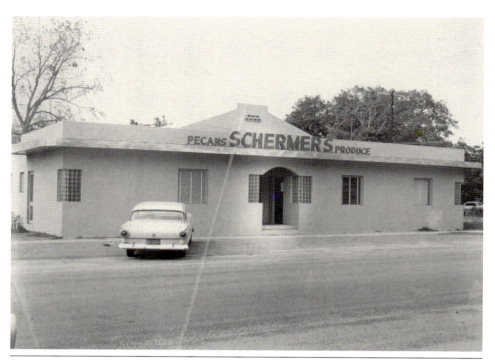

Alton and Lula Schermer opened Schermer's Pecan Company in 1946. It occupied a whole city block on Fairhope Avenue between Bancroft Street and North School Street and processed 500,000 pecans annually. The site was also home to Fairala, a wholesale produce-handling and shipping company. The Schermers retired in 1971 and sold the company to a Georgia family that still owns the company. The buildings were demolished, and the Fairhope Public Library opened there in 2007. (Past, Fairhope Single Tax Corporation Online Archives.)

The Fairhope Garage was built by Dyson and Sons in 1924 near the site of Fairhope's first school, which was a small frame building. The garage was owned for several years by Howard Ruge, who was Fairhope mayor from 1934 to 1948. A popular mayor, Ruge guided Fairhope through the Great Depression and World War II. Other businesses at this location included a chicken hatchery and Simmons Feed and Seed. Objects Gift Shop currently occupies the site.

Greer's Market No. 26 was built in 1928 on the northwest corner of De La Mare Avenue and Section Street. Constructed by Oswalt Forster, it was the first chain store to be located in the business center. In 1916, Greer's founder Autry Greer opened his first store in Mobile. The market became a pioneer of the cash-and-carry concept. In the 1960s and 1970s, the building was home to Davis Fashion Corner; it is currently Crown and Colony Antiques.

Section St. cor. Delamare Looking North

The Bank of Fairhope, the town's first bank, was built in 1917 on the corner of Johnson Avenue and Section Street. This picture was taken shortly after a car accident in 1921, according to a *Fairhope Courier* report. The Bank of Fairhope was the only bank in Baldwin County that remained open throughout the Crash of 1929 and the Great Depression. A century later, Fairhope has 26 banks. The original Bank of Fairhope location is now occupied by Dr. Music.

In 1950, Greer's moved from its original Fairhope location on De La Mare Avenue and Section Street to 75 South Section Street, and it has been in continuous operation at that location ever since. The building was reportedly designed by early Fairhope Colony pioneer W.A. "Bill" Dealy and constructed by Fairhope contractor Axil Johnson, whose home still stands at 751 Edwards Avenue. After it was completed', the store was admired for its modernity.

Frank Stewart, known as the Picture Man, established a photography business in Silver Hill in 1906 before moving to Fairhope and relocating his business there in 1909. In 1918, Stewart opened the Fairhope Photo Shop on the end of the block between Section Street, Bellangee Avenue, and Bancroft Street. In 1938, Stewart sold the business, but it continued to operate under the same name until the 1960s. Today, Bouch's cigar shop and the Pitman Insurance building occupy that location.

In 1944, Jack and Ellis Ponder started a plumbing, heating, and electrical repair business called Ponder Brothers in Fairhope. A year later, Jack took over the business and had a new building erected on the southwest corner of Section Street and Magnolia Avenue, naming the business Ponder Company, which was successful for several decades. Today, the building houses East Bay Clothiers.

CHURCHES AND COMMUNITY BUILDINGS

The Fairhope Christian Church was located on the southwest corner of Church Street and St. James Avenue. The church was organized on September 8, 1896, and charter members included the Gaston, Mershon, and Lowell families, among others. The congregation moved into a building on Fairwood Avenue in 1961, and Fairhope's first church building was torn down in 1965.

The home of Theatre 98 Playhouse, located at 350 Morphy Avenue, was originally Fairhope Baptist Church and was built by contractor Eugene Lawrence in 1924 using a smooth and textured cement block locally known as a Dyson block. An addition was built in 1946, and the Baptist congregation relocated to the church's present location on Section Street. The building served as a city adult recreation center until 1985, when it became the home of Theatre 98.

CHURCHES AND COMMUNITY BUILDINGS

In 1915, there were 20 Quaker families living in Fairhope. The Friends Schoolhouse on the left was started in 1916 for children of Quaker families and served as the Friends meetinghouse. The meetinghouse was constructed in 1919 and cost $1,346.65. In 1951, nine Quaker families from Fairhope left the United States because of their pacificist beliefs and established Monteverde, a community in Costa Rica. The Friends continue to worship in their original meetinghouse at 9261 Fairhope Avenue.

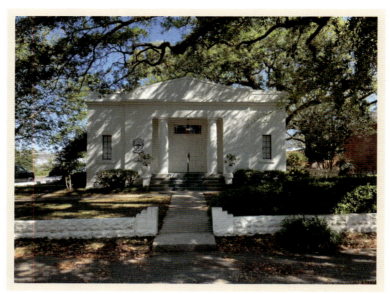

The First Church of Christ, Scientist, at 301 Fels Avenue was built by Oswald Forester and Sons in 1931. The unique Greek temple–style church building is located on the northeast corner of Church Street and Fels Avenue, a predominantly residential street named for Fairhope benefactor Joseph Fels. Fels was a single-tax supporter who earned his fortunes with Fels Naptha Soap, which was used to lubricate the rails to launch the colony's first *Fairhope* bay boat.

CHURCHES AND COMMUNITY BUILDINGS

St. Lawrence Church was built on South Bayview Street near the western dead end of Gaston Avenue and South Bayview Street in 1922. George Lucassen built the church, and his son Bernard was the first baby baptized there. The church was demolished when the current St. Lawrence Church was built on South Section Street in 1953. The Forestdell Development Company built homes on De Ferriet Court beginning in 1962, with the Kingsberry Homes Collier model listed for sale at $11,350.

The *Fairhope Courier* newspaper office, print shop, and community bulletin board were centrally located. The current Fairhope Single Tax Corporation headquarters (and former *Fairhope Courier* office) was constructed in 1924. Made of Clay City tile, a locally made structural clay tile, the structure at 336 Fairhope Avenue was built by local builder Marmaduke Dyson. Ernest Berry Gaston started the *Fairhope Courier* in 1894. It was owned and operated by three of Gaston's children (Arthur, Cornelius, and Frances Gaston Crawford) until they sold the paper in 1963. (Past, Fairhope Single Tax Corporation Online Archives.)

CHURCHES AND COMMUNITY BUILDINGS

The Fairhope Single Tax Corporation leased land on Oak Street to Edith and Converse Harwell in 1938. Edith Harwell was already a nationally recognized potter from North Carolina known by her artist's mark, "Pinewood Pottery." The Harwells built the new Pinewood Pottery on this lot. The Eastern Shore Art Association was founded in 1954. In 1961, the Harwells donated the lease and improvements to the Eastern Shore Art Association to build the art center, which opened in 1965.

The Eastern Shore Yacht Club was built in 1919 after the 1916 hurricane destroyed the Mobile Bay Yacht Club. The Parker family turned the place into the La Corona Club nightclub for several years. In 1952, Fairhope Elks Lodge No. 1879 was established, and a year later, the Elks moved into their new headquarters. The building was destroyed by a fire in 1962, and the current lodge was constructed at 561 South Mobile Street. (Past, Fairhope Single Tax Corporation Online Archives.)

CHURCHES AND COMMUNITY BUILDINGS

OBILE BUSINESS WOMENS CLUB, FAIRHOPE, ALA.

American Legion Post 199 was originally used as the meeting place for the Mobile Business Women's Club from 1913 until about 1929. The building was designed by architect George Bigelow Rogers, who had designed the Van Antwerp skyscraper of Mobile, among other buildings. After a decade as a nightclub, and thanks to the efforts of longtime Legionnaire Dr. Claude Godard, the American Legion's Eastern Shore Post opened in 1938. It was renamed Post 199 in 1962.

CHURCHES AND COMMUNITY BUILDINGS

The cornerstone for Pythian Castle, the meeting place for the Knights of Pythias Fairhope Lodge 268, a fraternal organization, was laid in April 1915. The building was completed in 1916, and the organization met upstairs. Businesses operated on the first floor, including the state-run ABC liquor store in the 1970s. Other groups also gathered upstairs, including the Fairhope Forum, a lively lecture and discussion group that covered a range of topics, from spiritualism to vegetarianism to political trends and theories.

CHURCHES AND COMMUNITY BUILDINGS

The Harry S. Greeno Masonic Lodge No. 598 F&AM was dedicated in February 1912. The land for the lodge was donated by Greeno, himself a Mason and Fairhope's first mayor. The first floor served as Fairhope's second post office from 1912 to 1932. H.C. Oswalt served as postmaster; his daughter Annie Mae Oswalt Winberg was Fairhope's first postmistress. A new lodge behind the original location opened in 1980. Creative Dance has occupied this building for more than two decades.

Four thousand people attended the dedication of Thomas Hospital in September 1960. Named for Georganna Thomas Ives, who donated the eight acres on the corner of Greeno Road and Morphy Avenue, the hospital was a 23,000-square-foot, one-story building with 8 doctors and 36 beds.

Only this small part of the original hospital remains. Today, the state-of-the-art hospital encompasses 368,000 square feet, has 189 beds, and employs 1,200 people, including more than 200 physicians.

CHURCHES AND COMMUNITY BUILDINGS

SCHOOLS AND CIVIC BUILDINGS

The School of Organic Education (pictured) was founded in 1907 by a Minnesota teacher named Marietta Johnson. The school soon included multiple buildings originally located on the block between Fairhope Avenue, Bancroft Street, Morphy Avenue, and School Street. Today, the block is occupied by Coastal Alabama Community College.

Organic School
Fairhope, Ala.

In need of a school, the Fairhope community completed this two-room schoolhouse in 1904. Then, to keep up with the growing population, Fairhope opened a larger school on Morphy Avenue and Church Street in 1910. The two-room schoolhouse, renamed the Bell building, was procured by the School of Organic Education (SOE). In 1986, the SOE moved to a schoolhouse on Pecan Avenue, and the Bell Building became incorporated into what is now the Coastal Alabama Community College campus.

SCHOOLS AND CIVIC BUILDINGS

Built in 1909 on the grounds of Marietta Johnson's School of Organic Education, this building was originally called the Manual Training Building. It was used for woodworking and other manual classes as well as classes in domestic sciences. In 1914, a new Manual Training Building was constructed, and the original was converted into a high school schoolroom and chemistry laboratory. The building is now named Dahlgren Hall after Harold Dahlgren, who provided funds for the building's restoration in 1981.

The Organic School Home, built in 1921, was a boardinghouse for students at the School of Organic Education. The home was located on the south side of Fairhope Avenue just east of Bancroft Street. Students from all over the country would stay at the home while they attended the world-famous school. Currently, the John Borom Center of the Coastal Alabama Community College sits approximately where the Organic School Home was located.

SCHOOLS AND CIVIC BUILDINGS

Less than two decades after the founding of Fairhope, the town's school-age population had outgrown the local school building's capacity. The town responded by building a new two-story public school on the corner of Morphy Avenue and Church Street in 1910. This building housed all of Fairhope's grade levels until a separate high school was built in 1925. The public school was demolished in 1979, and the site is now Fairhoper's Community Park.

The first building to house only the Fairhope Public High School was constructed in 1925 on Church Street across from the present-day location of Fairhoper's Community Park. The building served as the high school until 1953, when a new high school opened on North Section Street. The older building then served as an elementary school and a K-1 center. The building is currently undergoing renovations so it can be leased out to multiple educational organizations.

SCHOOLS AND CIVIC BUILDINGS

The old city hall was built in 1928 in the Mission Revival style by O. Forster and Sons. It originally housed the mayor's office, council chamber, jail, and "chemical and hose truck." Space was also provided for public gatherings. Over time, the building was converted into the Fairhope Police Station. In 2002, the police station moved, and in 2006, renovations began to prepare the building for use as the new Fairhope Museum of History. The museum opened in 2008.

The Fairhope Public Library opened on April 18, 1900, inside the home of its founder, Marie Stephens Case Howland, who donated her personal collection of 1,200 books to the library. The dedication took place in Howland's home (pictured on the left) around her dining room table. The original one-room library was built in front of Howland's home in 1908. Additions in 1919 and 1925 provided room to expand the collection, which also included a museum. (Past, Fairhope Public Library.)

Public Library Fairhope Ala

The Stewart The Picture Man

SCHOOLS AND CIVIC BUILDINGS

Built in the Italian Renaissance Revival style, the structure at 325 Fairhope Avenue was erected in 1932 to serve as the new post office. However, by 1964, a larger post office was required for Fairhope, and this building was taken over by the *Fairhope Courier*. A few years later, the Eastern Shore Chamber of Commerce took over the building, and it now serves as a bank. The words "United States Post Office" are still embossed above the building's doors.

The Fairhope Single Tax Corporation's nine-hole golf course opened in 1916 along Big Mouth Gully to provide recreation to tourists visiting the eastern shore community. The clubhouse of the Fairhope Golf, Gun, and Country Club was built south of Fairhope Avenue on what is now Johnson Avenue in 1922. The Fairhope Single Tax Corporation turned the operation of the golf course over to the city in the 1930s. The golf course closed in the 1950s and was subdivided. The clubhouse is now a private residence.

SCHOOLS AND CIVIC BUILDINGS

CHAPTER 6

HOMES

Fairhope founder E.B. Gaston and his family were the first to build a home in the newly formed Fairhope colony in January 1895. Their house, shown on the right, was built on Fairhope Avenue. Immediately after this house was finished, the Gastons began construction on the Mershon home, shown on the left. The Mershons were the family of E.B.'s wife, Clara.

The second home of the E.B. Gaston family was located at 118 Magnolia Avenue and was purchased by the Gastons from Rev. G.W. Wood in 1904. The home remained in the family for decades, and the upstairs was rented out as an apartment in the 1950s and 1960s. Soon after the 1960s, the home fell into disrepair but was purchased and prepared for future renovations. Those renovations are currently underway. (Past, Fairhope Single Tax Corporation Online Archives.)

This home on the northeast corner of Fairhope Avenue and Summit Street was built for Dr. Clarence L. Mershon around 1901. Dr. Mershon was an early Fairhope resident and the colony's first teacher and physician. He built the original Fairhope Pharmacy, which is still located on the southwest corner of Fairhope Avenue and Section Street. His doctor's office, which no longer stands, was located on the lot to the east of his home. (Past, Fairhope Single Tax Corporation Online Archives.)

The Columns is located on the northeast corner of Magnolia Avenue and North Bayview Street. The Neoclassical Revival home was completed in 1904 for J.J. Mogg, a Chicago coal merchant and devoted single-taxer. The Edward Slosson family purchased the property and lived in it for many years. The house is owned by descendants of the Mann family, a name so prominently known for their early contributions to the success of the colony that the town was nearly called Mannville.

The home on the southeast corner of Magnolia Avenue and North Bayview Street was built in 1906 for James Bellangee and his family. Known as "the professor" for his collegiate teaching experience, Bellangee traveled the United States professing the Fairhope Colony's plan and lobbied people to visit or settle in the fledgling community. Bellangee is on the far left in the past photograph. Bellangee was elected to Fairhope's first town council in 1908. (Past, Fairhope Single Tax Corporation Online Archives.)

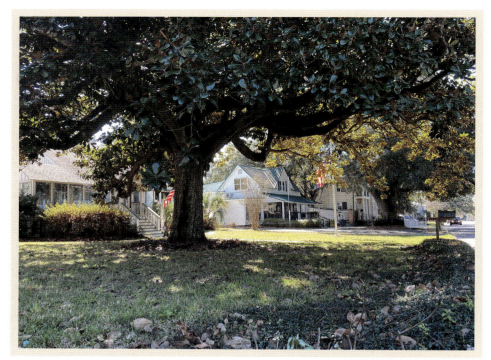

Dr. Harris Greeno's home at 107 South Mobile Street was known as White Gables and had marvelous bay views from atop the bluff. A physician in the Union army during the Civil War, Greeno was active in his community and served as Fairhope's first mayor. He was a Mason and donated the land for Fairhope's first Masonic lodge. A vocal critic of the Fairhope Single Tax Corporation, he was refused membership. (Past, Fairhope Single Tax Corporation Online Archives.)

This group of ladies posed outside the E.C. Slosson home at 51 North Bayview Street. The two young women in white dresses fourth and sixth from the left are the Slosson sisters, Lois Slosson Sundberg is on the left, and Ellen Slosson Boise, or Nell, is on the right. Lois was a renowned Fairhope photographer, and many of her family pictures were donated to the colony by her granddaughter Pinky Bass, a prominent artist and photographer. (Past, Fairhope Single Tax Corporation Online Archives.)

This home on South Bayview Avenue was built in 1925 by Fobes and Sheldon for Capt. Ed Roberts and his family. The Craftsman "Airplane Bungalow" is made from Clay City tile. A similar home can be found at the corner of De La Mare Avenue and Church Street. Captain Roberts was a bay boat pilot for the *Bay Queen* and other ships that plied the waters of Mobile Bay from the eastern shore to Mobile. (Past, Fairhope Single Tax Corporation Online Archives.)

J.M. Beckner's home was completed on Church Street in April 1906 and built by E.D. Brann. A few months later, a hurricane struck, but the home remained standing. Warren Stearns bought the home in 1912 and owned it until the 1980s. It was listed in the National Register of Historic Homes in 1988, when it was owned by the Baker family. In the 1990s, Tyler King opened the Fairhope Inn in the home. In 2019, current owner Paige Dawson purchased the inn.

This one-room structure was completed in 1926 by Henry James Stuart, who poured and laid each cement block by hand. Stuart bought 10 acres of wooded land in 1923, built this home, and called his property Tolstoy Park. Stuart lived a simple, shoeless, vegetarian lifestyle and made money weaving rugs, earning him the nicknames "Ye Old Weaver" and "The Hermit." The house currently sits in the same place off the northwest corner of Parker Road and US Highway 98.

In 1910, a unique individual named Emma Ida Schramm moved to Fairhope from Chicago and built a tall wood structure on stilts, naming it Trycadia Lodge. Trycadia Lodge was located on South Section Street across from where St. Lawrence Catholic Church now stands.

Schramm, sometimes referred to as the "bird woman," remained in Fairhope for 17 years before moving to South Carolina. Schramm's old lot is now occupied by a single-story brick building that houses a local radio station.

Judge Edward P. Totten, a devoted single-taxer, moved with his family from North Dakota into this home on Morphy Avenue in 1919. Pictured are, from left to right, Judge Totten, Parker, Clair, and Holly (who is holding Joyce). A fan of motion pictures, Judge Totten disliked watching movies at Comings Hall, so he had the Magnet Theatre built. Designed by Mobile architect J. Platt Roberts, the theater opened in 1924, and the interior was decorated in an Egyptian motif.

The home of A.P. Minnich was built around 1912. Minnich planted orange trees on his one-acre property next to the post office. Oranges and satsumas were an excellent cash crop until a big freeze in 1924 killed the citrus market. Pictured in the distance are the back of the Beckner house and Fairhope Christian Church. The Minnich home was demolished in 2015. The new building was completed in 2022, and Running Wild and Rae's Kitchen relocated there from previous locations.

Discover Thousands of Local History Books Featuring Millions of Vintage Images

Arcadia Publishing, the leading local history publisher in the United States, is committed to making history accessible and meaningful through publishing books that celebrate and preserve the heritage of America's people and places.

Find more books like this at
www.arcadiapublishing.com

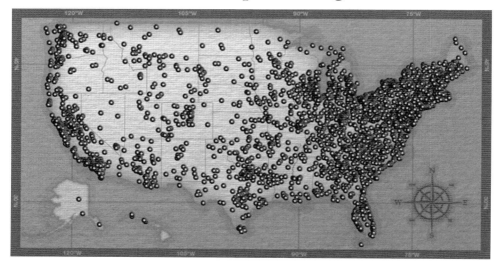

Search for your hometown history, your old stomping grounds, and even your favorite sports team.